YOUNG TURNER: EARLY WORK TO 1800

ANNE LYLES

Young Turner: Early Work to 1800

WATERCOLOURS AND DRAWINGS FROM

THE TURNER BEQUEST 1787–1800

THE TATE GALLERY

cover
**Traeth Mawr, with Y Cnicht and
Moelwyn Mawr?** 1799, detail (cat. no. 37)

ISBN 1 85437 026 X
Published by order of the Trustees 1989
Copyright © 1989 The Tate Gallery All rights reserved
Designed by Caroline Johnston and published by
Tate Gallery Publications, Millbank, London SW1P 4RG
Typeset in Monophoto Baskerville
Printed by Balding + Mansell plc, Wisbech, Cambs
on 150 gsm Parilux Cream

Contents

Foreword

This catalogue records the exhibition which took place in the Clore Gallery in January–March 1988, the first of a projected series of small exhibitions examining Turner's work on paper decade by decade. At that time, catalogues were not envisaged for such shows; but the popular success of the project has encouraged us to embody the contents of the exhibition in a publication which accordingly takes its place as the first of a series of six similar catalogues. The second show in the sequence, 'The Second Decade', took place in the Winter of 1989, and a catalogue is already available.

It seemed appropriate that the Clore Gallery should inaugurate its regular programme of changing exhibitions drawn from the Turner Bequest with a sequence of displays entering in some detail into Turner's development as it is revealed in the works on paper. These offer an unparalleled insight into the artist's mind, and greatly enrich our understanding of his creative procedures. His development throughout a long career of unceasing innovation can be examined, stage by stage, almost year by year; the whole story of his art can uniquely be told from the resources held in the Clore Gallery, and there can be no more fitting way of signalling the new facilities for study and display that it provides.

There is a popularly held view that Turner began his career as a somewhat pedestrian imitator of the prevailing topographical style of the late eighteenth century, and that only gradually – perhaps not until the latter part of his career – did he evolve the visionary art on which his fame should rest. This exhibition demonstrates the error of such an estimate. From his earliest years he was inventive, experimental and original. He admired and imitated the topographers, certainly, as he was later to admire and imitate Claude and Poussin and Titian; but he was always searching for ways to build on what they had taught him. His own sensitivity to effects of light and to the human vitality that informs serious landscape painting is apparent from even such early works as the 'Back View of the Hot Wells' and 'Don Quixote' of 1792–3; and thereafter, year by year, he can be seen evolving new techniques to match his constantly enlarging perceptions of nature. By 1793 he had begun to refine his methods of depicting water in motion; by 1794 he was capable of masterly evocations of atmosphere like the view of 'Valle Crucis and Dinas Bran'. His experience of Rembrandt and Piranesi set him new challenges which he took up triumphantly in the ambitious interiors of the middle years of

the decade; and his visits to the Welsh mountains in 1798 and 1799 inspired a series of watercolour studies which had never been equalled for expressive grandeur and subtlety of understanding. In the preparatory sheet that he made for a view of Snowdon from above Traeth Bach in the winter of 1798 (when, it should be remembered, he was still only 23), he resolved new technical problems with a mastery and originality which match any that appears in his later work. It is a tale of relentless progress, stemming from a brilliantly intelligent grasp of the technical and conceptual problems facing the landscape painter. If Turner had died in 1800 he would, on the evidence of this exhibition, have been the grandest and profoundest of European landscape painters. It is hard to believe that there remained fifty years of astonishing development before him.

We are grateful to Anne Lyles, the organiser of the exhibition and compiler of this catalogue. She would like to thank Anne Buddell, Evelyn Joll, Janet Peatman, Richard Seddon and Richard Spencer for their generous help.

Andrew Wilton *Curator of the Turner Collection*

Introduction

The early years of Turner's career saw radical advances in his use of watercolour. During the period covered in this exhibition, the years 1787 to 1800, he confronted and rapidly mastered the artistic challenges presented by an ever-widening range of subject-matter. From modest beginnings as a boy of twelve, evident here in the rather tentative and awkward drawing of Nuneham Courtenay (cat. no. 1), he had matured within the space of little more than a decade into an artist of great sensitivity, subtlety and sophistication, capable of such astonishing *tours de force* as the large Welsh colour studies of circa 1798 to 1799 (cat. nos. 36–38 and 41). By the end of the century he received professional recognition with his election as an Associate of the Royal Academy on 4 November 1799, testimony to the remarkable strides he had made during these crucial apprenticeship years.

As a young boy Turner trained under the architectural draughtsman Thomas Malton (1748–1804), and many of his earliest watercolours, such as 'View of Westminster with Henry VII's Chapel' 1790 (cat. no. 2) and 'Tom Tower, Christ Church Oxford', 1792 (cat. no. 4) are stylistically indebted to the work of Malton and other topographers like Edward Dayes (1763–1804), Thomas Hearne (1744–1817) and Michael Angelo Rooker (1746–1801). In December 1789 he had been admitted as a student at the Royal Academy Schools where, after three years copying from casts of antique sculpture, he progressed to making drawings at the life class from the nude model (cat. no. 9). Perhaps it was his interest in drawing the human figure at this time which prompted him to try his hand at a subject from the more ambitious sphere of literary illustration; his two lively pen and ink designs of *c*. 1792–3 from Cervantes' *Don Quixote* (cat. nos. 7–8) mark an important early attempt to integrate the figure within its landscape setting.

Turner's chief interest in the first half of the decade, however (and his main source of income), lay in exploiting the fashionable market for antiquarian and topographical views. To this end he embarked on a wide succession of tours throughout Britain – he visited the West Country in 1791 (cat. no. 3), the Midlands in 1794 (cat. nos. 10–11) and Wales three times by the middle of the decade (cat. nos. 5, 12–15 and 17–18) – in search of picturesque material which could readily be translated from drawings recorded in sketchbooks into watercolours suitable for sale or exhibition. 'The Ruins of Valle Crucis' (cat. no. 13) is an example of such

a finished work, perhaps commissioned from Turner but for some reason never delivered to the patron in question; 'Llandaff Cathedral' (cat. no. 18), meanwhile, which he exhibited at the Royal Academy in 1796, although apparently intended for the 'Dr Matthews' whose name is inscribed on the reverse of the preparatory study, was similarly destined never to leave the studio.

Until 1796 Turner remained almost exclusively a watercolour painter, his technique restricted to the conventional application of monochrome or coloured washes over pencil which he had learned under Malton (see, for example, cat. no. 2) and when copying the watercolours of John Robert Cozens (1752–97) at the house of Doctor Monro (1759–1833), such as 'Montecassino' (cat. no. 23). In 1796, however, the year he exhibited his first oil at the Royal Academy, 'Fishermen at Sea' (Gallery 107), Turner began experimenting with coloured papers and with the denser medium of bodycolour or gouache – that is watercolour mixed with an opaque white. The pages of the *Wilson* sketchbook of 1796–7 (cat. no. 22) are prepared with a reddish-brown wash, thus providing a coloured ground analagous to the dark ground of an oil painting; and most of the subjects are executed in a mixture of watercolour and bodycolour – as indeed are the technically similar marine studies of the same date (cat. nos. 19–21). Turner was to continue using bodycolour and coloured papers throughout his career. The techniques of 'blotting' or 'stopping out', on the other hand, which he also developed about this time, are particularly associated with his work of the late 1790s. By means of these methods surface colour could either be partially removed through blotting, or masked in selected areas with a 'stopping out' agent such as gum to prevent it being obscured by subsequent wash layers, thus revealing a preparatory wash or the white of the paper beneath. The technique of 'stopping out' is particularly noticeable in watercolours of *c*.1798–1800, such as 'Norham Castle' (cat. no. 28), 'The Bend of a River (the Wye?) under High Cliffs' (cat. no. 34), and especially 'Oxford: the Interior of Christ Church Cathedral' (cat. no. 30).

'Oxford: the Interior of Christ Church Cathedral' belongs to a group of large-scale architectural interiors dating from the latter half of the decade. Although unfinished, with its rich and dramatic contrasts of light and shade it recalls as do others in the series the prints of Piranesi, examples of which Turner would have seen in the collection of his patron, Sir Richard Colt Hoare (1758–1838) of Stourhead in Wiltshire. Turner probably first visited Stourhead in 1795, when he was commissioned by Colt Hoare to make a series of drawings of the city and cathedral of Salisbury. Later in the decade he made two watercolours of the lake at

Stourhead (cat. nos. 42–3), perhaps in response to another commission from Colt Hoare. Certainly the artist received a variety of commissions from aristocratic patrons during the mid- to late 1790s to make drawings of their houses and estates: these included Edward Lascelles of Harewood House; Viscount Malden of Hampton Court, Herefordshire; the Earl of Yarborough of Brocklesby Hall for whom he made a finished watercolour of the Mausoleum designed by the architect James Wyatt (1746–1813) (a related study is cat. no. 29); and William Beckford of Fonthill (1760–1844) for whom he painted five large watercolours showing the Abbey at different times of the day (a preparatory study is cat. no. 45; see also cat. nos. 44 and 46).

It was, however, the grander scenery of North Wales which prompted the most rapid advances in Turner's vision towards the end of the decade. Up until 1798 it had been the picturesque abbeys, cottages, valleys and coastal stretches of South Wales (cat. nos. 5, 12–14 and 18) which had impressed him; in 1798 and 1799 it was the more sublime and mountainous scenery of North Wales. On his return from his tour of the North of England in 1797, he had already begun to work on a larger scale in watercolour. The unfinished study of 'Derwentwater' (cat. no. 27), which displays a new feeling for space, light and atmosphere, and the colour sketch of 'Norham Castle' of c.1798 (cat. no. 28) with its extra-ordinary bold handling, anticipate the large experimental colour studies of North Welsh landscape of 1798 to 1799 (cat. nos. 36–38, 41) which are unprecedented in Turner's work thus far and unparalleled thereafter. Some tranquil and expansive ('Traeth Mawr', cat. no. 37), others brooding and mysterious ('Nant Peris', cat. no. 38), they reflect his growing interest in the Sublime.

About 1799 Turner planned a series of watercolours relating to the story of the extermination of the Welsh Bards by Edward I – a subject popularised by Thomas Gray in his poem 'The Bard' (1755) and a favourite theme with history painters in this period. Most of them, like the colour study 'Looking down a Deep Valley towards Snowdon, with an Army on the March', (cat. no. 41), remained unfinished. 'Caernarvon Castle' (cat. no. 40), however, which shows a Bard singing in a broad classical landscape inspired by Claude, was exhibited by Turner at the Royal Academy in 1800. Like 'The Siege of Seringapatam' (cat. no. 47), his first watercolour to treat an ambitious subject from 'modern history', 'Caernarvon' employs ideas and themes which were subsequently to be taken up by him in oil; they point the way forward to his full maturity as an artist.

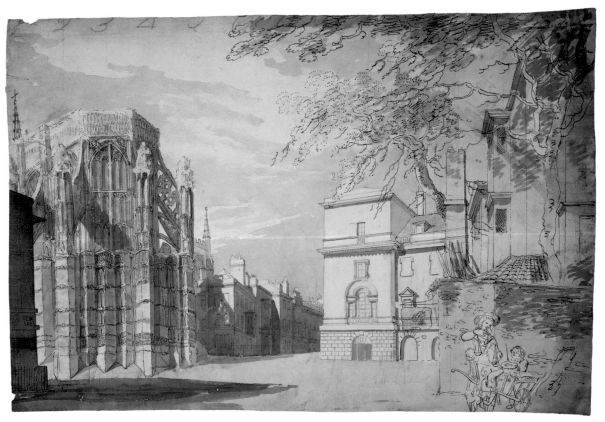

2 **View of Westminster with Henry VII's Chapel** *c.*1790

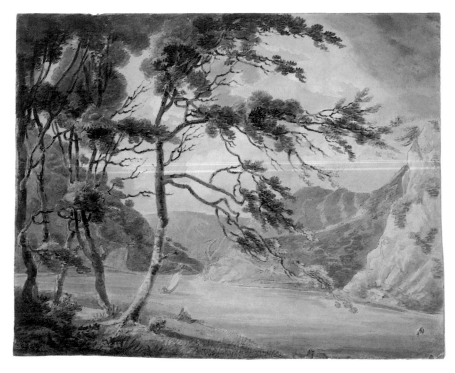

3 **The Avon near Wallis's Wall** 1791

16 **Colwell Bay** from the *Isle of Wight*
sketchbook 1795

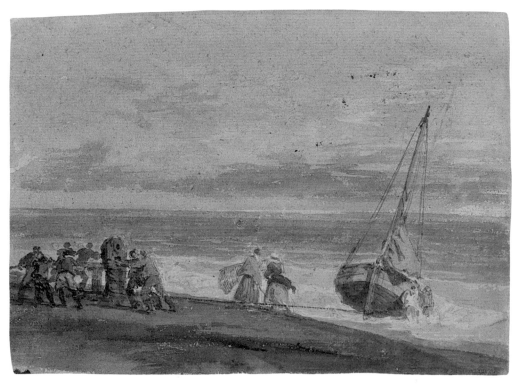

19 **Fishermen Hauling a Boat through Surf
on a Windlass** *c*.1796

24 **Fountains Abbey** from the *Tweed and Lakes* sketchbook 1797

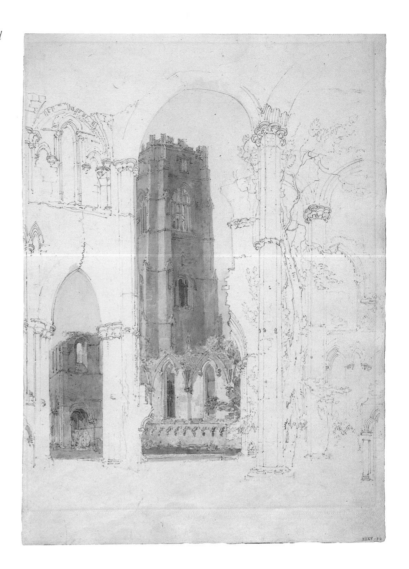

26 **Dunstanborough Castle from the South** 1797

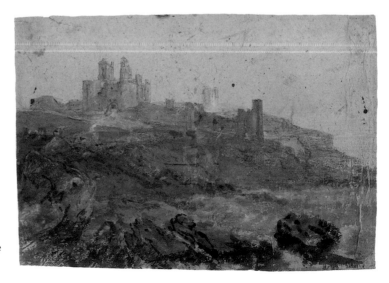

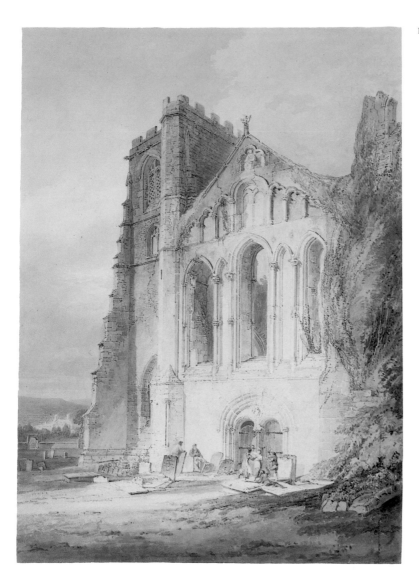

18 **Llandaff Cathedral: the West Front** 1795–6

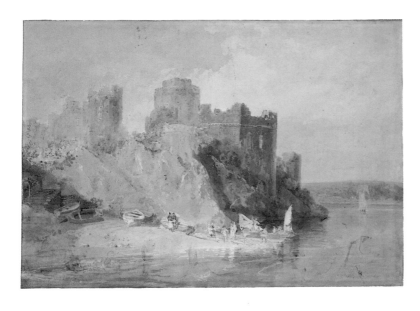

35 **Pembroke Castle** c.1798

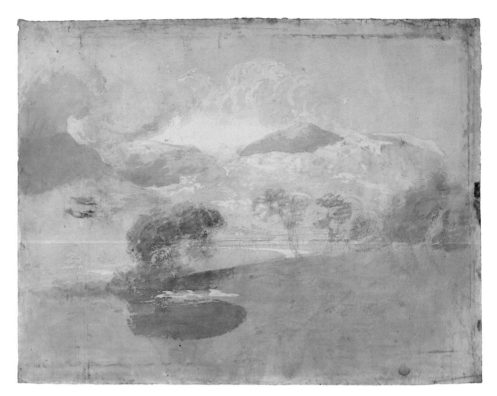

36 **View towards Snowdon from above Traeth Bach, with Moel Hebog and Aberglaslyn?** 1789-9

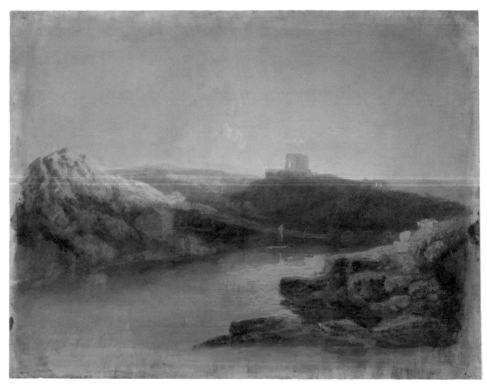

28 **Norham Castle: Colour Study** *c.*1798

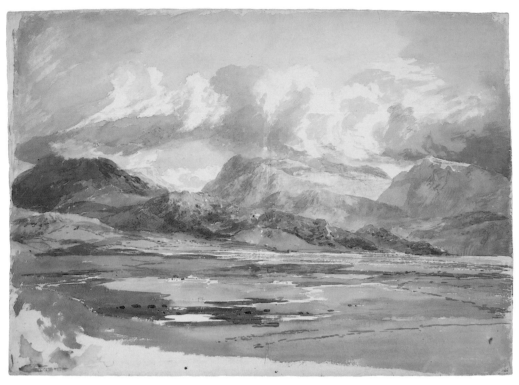

37 **Traeth Mawr, with Y Cnicht and Moelwyn Mawr?** 1799

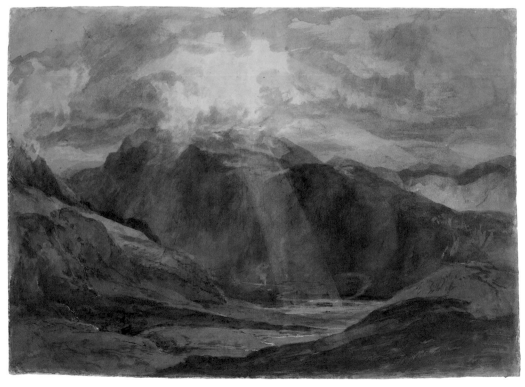

38 **Nant Peris, Looking towards Snowdon?** 1799–1800

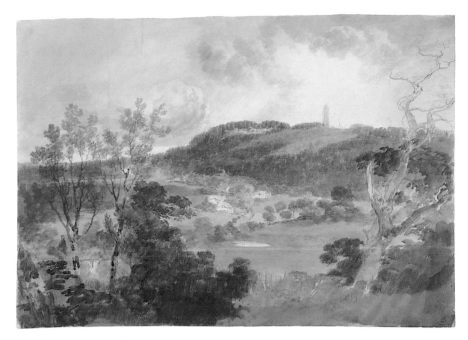

45 **View across a Valley towards the Tower of Fonthill Abbey** *c.*1799–1800

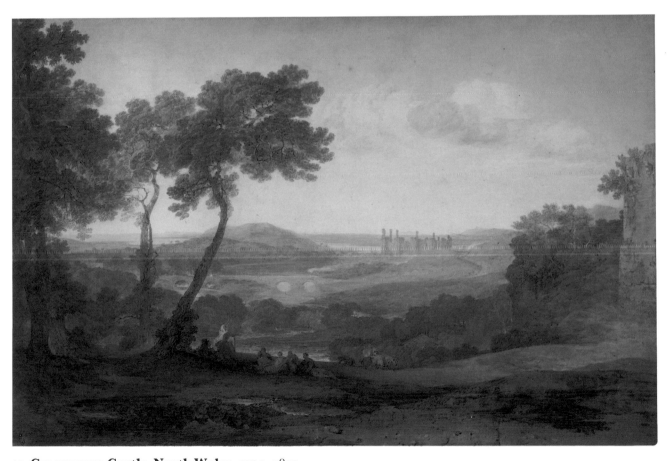

40 **Caernarvon Castle, North Wales** 1799–1800

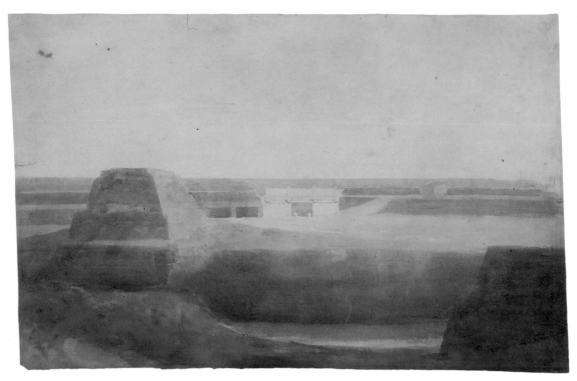

48 **Study of the Ramparts of Seringapatam**
*c.*1800

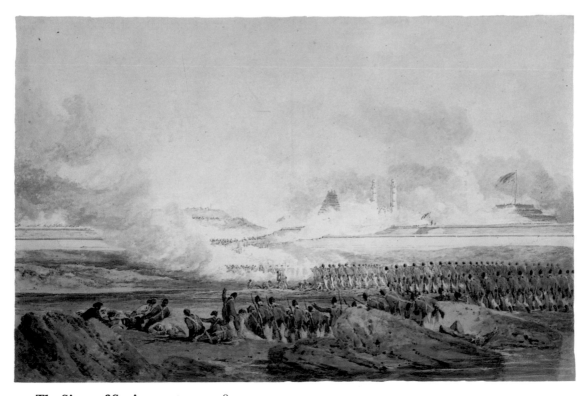

47 **The Siege of Seringapatam** *c.*1800

Catalogue

Measurements are given in millimetres followed by inches in brackets; height precedes width. Those for sketchbooks refer to size of sheet.

'w' refers to the catalogue of watercolours in Andrew Wilton's *The Life and Work of J. M. W. Turner*, 1979; 'B&J' refers to the catalogue of *The Paintings of J. M. W. Turner*, 1984, by Martin Butlin and Evelyn Joll.

Works illustrated in colour are marked *

1 **View of Nuneham Courtenay from the Thames** 1787
Watercolour over pencil
318 × 447 ($12\frac{1}{2} × 17\frac{5}{8}$) sheet;
302 × 422 ($11\frac{7}{8} × 16\frac{5}{8}$) image
Inscribed: 'W Turner 1787'
Turner Bequest; I B
D00002

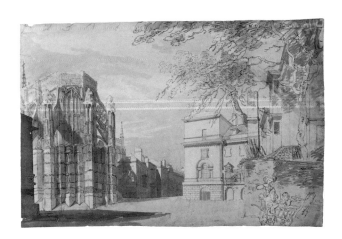

This watercolour is one of the artist's earliest dated works; another drawing signed and dated to the same year, 'Folly Bridge and Bacon's Tower, Oxford' is also in the Turner Bequest (TB I A). Two years later Turner made a drawing of Nuneham Courtenay from a similar viewpoint on a page of the *Oxford* sketchbook (TB II 6), used when he was staying with his uncle at Sunningwell. This watercolour, however, like 'Folly Bridge', may have been copied from a print.

2 **View of Westminster with Henry VII's Chapel*** *c*.1790
Pen and watercolour over pencil
308 × 450 ($12\frac{3}{16} × 17\frac{3}{4}$)
Private Collection

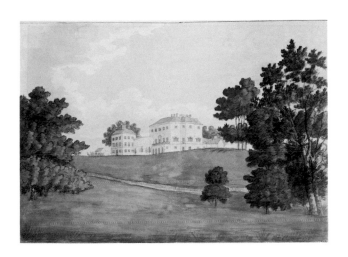

Towards the end of 1789 Turner was apprenticed to the architectural draughtsman Thomas Malton from whom he learned the style of the late eighteenth-century 'tinted drawing', of which this is a good example; layers of grey wash would be applied over detailed under-drawing to establish areas of light and shade before the addition of local colour. Turner has squared his drawing for enlargement using a numbered grid similar to those adopted in the *Oxford* sketchbook of *c*.1789 (TB II), and has also pasted on additions to the buildings on the left. A slight pencil sketch in the Bequest, drawn on the back of an anatomical study made by the artist at the Royal Academy Schools (TB X A), and showing a woman, child and wheelbar-

row, is related to the group of figures to the right. A watercolour of Westminster by Malton in the British Museum, dating from the late 1780s, shows a similar view looking across Old Palace Yard although from a more distant viewpoint in Abingdon Street.

3 **The Avon near Wallis's Wall*** 1791
Pencil and watercolour with pen and brown ink
237×294 ($9\frac{5}{16} \times 11\frac{9}{16}$)
Turner Bequest; VII B
D00109

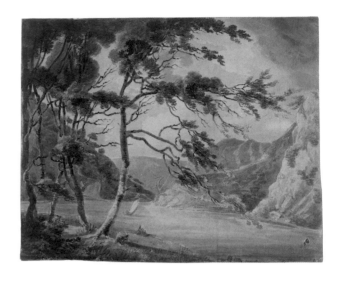

In September 1791 Turner went to stay with his father's friends, the Narraway family, in Bristol; he sketched so extensively in the Avon Gorge at Clifton that they nicknamed him 'the Prince of the Rocks'. This sheet is very close, in its palette of blues and greens and with its prominent foreground branches framing the distant vista, to a view of 'The River Avon from Cook's Folly' in the *Bristol and Malmesbury* sketchbook of 1791 (TB VI 24). Both drawings seem to have been intended for publication as engravings in a set of 'Twelve Views on the River Avon', although the project failed to materialise.

4 **Tom Tower, Christ Church, Oxford** 1792
Pencil and watercolour
272×215 ($10\frac{11}{16} \times 8\frac{7}{16}$)
Turner Bequest; XIV B
D00155

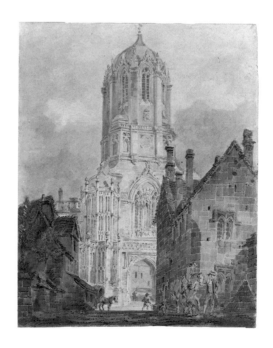

With its restrained palette, the play of light and shadow across the irregular brickwork of picturesque buildings and the inclusion of foreground figures to enliven the scene, this work is typical of many of Turner's early topographical drawings which show the influence of the watercolourists Edward Dayes, Thomas Hearne and Michael Angelo Rooker. Another, slightly larger version of the subject from about the same date is in a private collection (W.38); both are based on a pencil study in the Turner Bequest (TB XIV A).

5 **Llandewi Skyrrid with Skyrrid Mawr?** 1792
Pencil and watercolour
285 × 375 ($11\frac{3}{16}$ × $14\frac{3}{4}$) border;
245 × 337 ($9\frac{5}{8}$ × $13\frac{1}{4}$) image
Turner Bequest; XII P
D00145

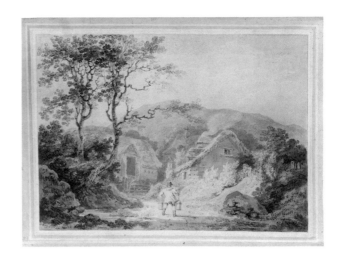

This watercolour probably shows Llandewi Skyrrid or Skirrid Farm with the 'Holy Mountain' of Sgyryd between Abergavenny and Llanthony in the distance. It seems to have been commissioned by the 'Mr Brydges' whose name is inscribed on a pencil study for the subject (TB XII N) made by Turner on his first trip to Wales in 1792. It is clearly a finished watercolour, as is emphasised by Turner's inclusion of a grey washline border around the margin of the image. This late eighteenth-century practice was generally superseded in the early nineteenth century by the use of gilt mounts or frames.

6 **Back View of the Hot Wells, Bristol** 1792–3
Pencil and watercolour
184 × 256 ($7\frac{3}{8}$ × $10\frac{1}{8}$)
Turner Bequest; XXIII O
D00389

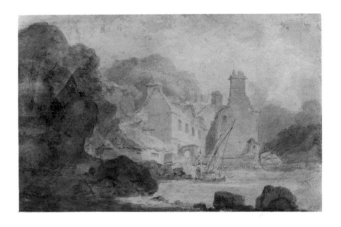

This view, closely based on a pencil drawing in the *Bristol and Malmesbury* sketchbook of 1791 (TB VI 3), has recently been identified as the study for the watercolour which Turner exhibited at the Royal Academy in 1793 with the title 'The Rising Squall – Hot Wells, from St. Vincent's Rock, Bristol' (present whereabouts unknown). It is one of the earliest examples of his work to show an interest in light and atmosphere – qualities presumably also a feature of the finished watercolour about which the critic Peter Cunningham was to write in his obituary of Turner in 1851 that it 'evinced for the first time that mastery of effect for which he is now so justly celebrated'.

7 **Preparatory Sketch for 'Don Quixote and the Enchanted Barque'** 1792–3
Pen and grey wash over pencil
168 × 230 ($6\frac{5}{8}$ × 9)
Private Collection

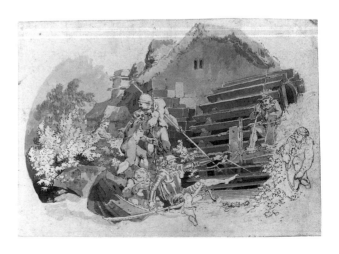

The vigorous penwork and lively presentation of this comic sketch reveals Turner's stylistic debt at this date to the drawings of his contemporary, P. J. de Loutherbourg (1740–1812). It was subsequently elaborated and reworked to produce a more finished version of the subject (cat. no. 8), which demonstrates the care which Turner took with composition from an early age. The

cottage, its stone roof overgrown with weeds and its side elevation only partially rusticated, is very close to that in the watercolour of 'Llandewi Skyrrid' (cat. no. 5).

8 **Don Quixote and the Enchanted Barque** 1792–3
Pen and grey wash over pencil
299 × 381 (11$\frac{13}{16}$ × 15) sheet;
279 × 359 (11 × 14$\frac{3}{16}$) image
Private Collection

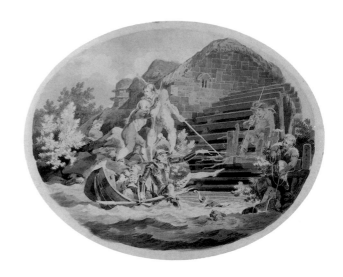

This elaborate composition from Cervantes' *Don Quixote* (Book II, chapter 29) is Turner's earliest finished attempt at literary illustration. Don Quixote, the famous Knight of the Sad Countenance and his 'Squire' Sancho Panza, both seated in the 'enchanted' boat, have just been saved from being dragged under the mill-stream thanks to the timely intervention of the courageous millers. Don Quixote, mistakenly imagining the millers to have incarcerated some innocent victim of high rank, has just drawn his sword, only to collapse in the boat (a pencil study for the figure of Don Quixote is in the Turner Bequest, TB XVII N). Sancho Panza prays to be rescued from imminent peril; his expression is more developed than in the preliminary study (cat. no. 7), and his face now turned in three-quarter profile.

9 **Academy Study of a Kneeling Male Nude** *c*.1794–5
Black, white and red chalks
463 × 292 (18$\frac{1}{4}$ × 11$\frac{1}{2}$)
Turner Bequest; XVIII B
D00197

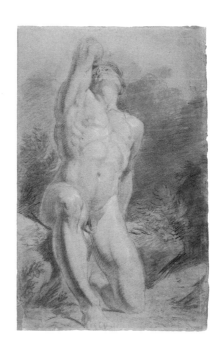

In December 1789 Turner was admitted as a student at the Royal Academy Schools. New students were first required to attend classes of the 'Plaister [Plaster] Academy' to copy casts of antique sculpture before graduating to the 'Life Academy' to draw from the nude model, who was often set in poses reminiscent of classical sculpture. This drawing, one of a number made by the artist at the life class between 1792 and 1799, may show a dying Niobid, one of the fourteen children of Niobe slain by Apollo and Diana to punish Niobe's arrogance.

10 **Lincoln Cathedral: the South-East Porch with the Chantry Chapel of Bishop Russell** 1794
Pencil
275×214 ($10\frac{7}{8} \times 8\frac{3}{8}$)
Turner Bequest; XXI P
D00343

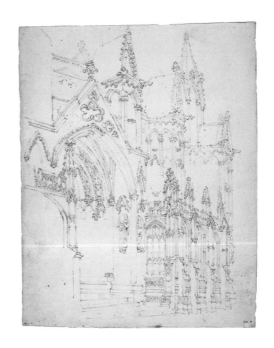

In the summer of 1794 Turner toured the Midlands, making many sketches of its picturesque sites and famous cathedrals such as Lincoln, Ely and Peterborough. This example shows the highly decorative if somewhat stylised manner of draughtsmanship which is characteristic of Turner's architectural drawings of the 1790s; the sequence of dots, dashes and curls, the thickening and thinning of line, which is particularly suited to capturing the knobbly texture of Gothic stonework. A similar drawing style was employed by Turner's famous contemporary, Thomas Girtin (1775–1802).

11 *Matlock* sketchbook 1794
The Bridge and Gatehouse, Bridgnorth
Pencil
111×181 ($4\frac{5}{16} \times 7\frac{1}{8}$)
Turner Bequest; XIX 20
D00228

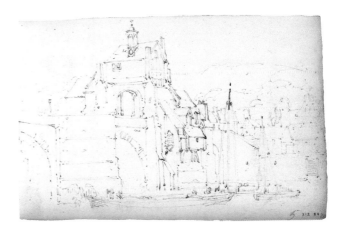

Turner's Midland tour of 1794 was undertaken in response to a commission to provide illustrations for John Walker's *Copper-Plate Magazine*, one of a number of small serial publications which were fashionable at the end of the eighteenth century. This drawing of Bridgnorth provided the basis for a finished watercolour (w.90; present whereabouts unknown) which was engraved for the magazine in 1795.

12 View of Llangollen, with the Dee in the Foreground 1794–5

Pencil and watercolour with some scraping-out
243 × 278 ($9\frac{9}{16}$ × 11) washline mount; 172 × 210 ($6\frac{3}{4}$ × $8\frac{1}{4}$) image
Turner Bequest; XXXII E
D00861

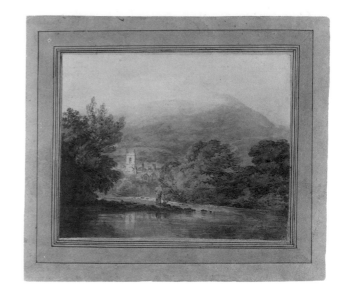

Turner made a brief incursion into North Wales on his return from the Midlands in 1794, and was much impressed by the Vale of Llangollen. The small size of this watercolour suggests that it may have been washed in at a later date over a pencil sketch made on the tour itself, rather than being elaborated in the studio. The somewhat crude grey wash ruled mount added by Turner (see also under cat. no. 5) indicates that this is a finished watercolour, perhaps intended for sale.

13 The Ruins of Valle Crucis Abbey, with Dinas Brân beyond 1794–5

Pencil and watercolour with some scraping-out
464 × 375 ($18\frac{1}{4}$ × $14\frac{3}{4}$)
Turner Bequest; XXVIII R
D00703

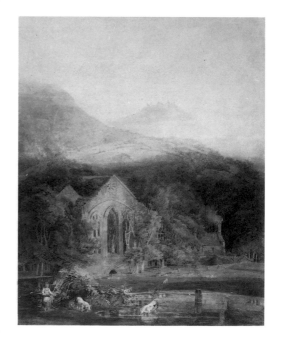

This dramatic watercolour relies for its impact on the subtle handling of light and shade. The ruin of the Cistercian abbey of Valle Crucis, overgrown with weeds, is almost lost in shadow, forming an eerie silhouette against the darkness of the hills behind; above, in the misty distance, looms the ruin of the thirteenth-century stone castle of Dinas Brân, temporarily illuminated in a burst of sunlight. Like the 'View of Llangollen' (cat. no. 12), this is a finished watercolour; both are early examples to show Turner's use of scraping-out, whereby colour is scratched away to reveal the white of the paper below.

14 Llanstephan Castle by Moonlight, with a Kiln in the Foreground 1795
Pencil and watercolour
213 × 281 ($8\frac{3}{8} \times 11\frac{1}{16}$)
Turner Bequest; XXVIII D
D00689

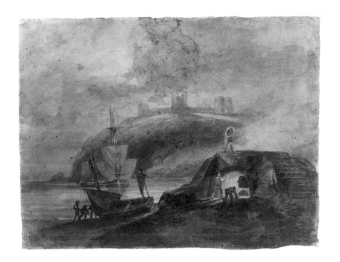

Turner's tour to South Wales in 1795 was more thoroughly prepared than the Welsh tours of previous years; he planned an itinerary and took two sketch-books of differing sizes (see cat. no. 15). This water-colour is based on a pencil drawing in the larger of these, the *South Wales* sketchbook (TB XXVI). Its theme is the contrast between the romantic silhouette of the ruins of Llanstephan Castle, commanding the estuary of the River Towy in the distance, and the prominent lime kiln being busily stoked in the foreground – between picturesque ruins and modern industry. The further contrast of moonlight and firelight, perhaps inspired by the paintings of Joseph Wright of Derby (1734–97), was one which Turner also used in his first exhibited oil painting, 'Fishermen at Sea' 1796 (Gallery 107).

15 *Smaller South Wales* sketchbook 1795
Landscape with Ploughed Fields in the foreground
Pencil and watercolour
130 × 205 ($5\frac{1}{8} \times 8\frac{1}{8}$)
Turner Bequest; XXV 28
D00489

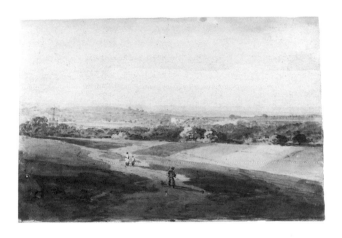

This is the smaller of the two sketchbooks which Turner took with him to Wales in 1795 (see under cat. no. 14). Most of the pages bear slight pencil sketches of Welsh towns. This is one of the few leaves to have been washed in with colour; Turner has also made a number of colour trials on the opposite page.

16 *Isle of Wight* sketchbook 1795
Colwell Bay, Isle of Wight; Fishing Boats and Pots*
Pencil and watercolour
264 × 204 ($10\frac{3}{8} \times 8$)
Inscribed: 'Colwell'
Turner Bequest; XXIV 43
D00451

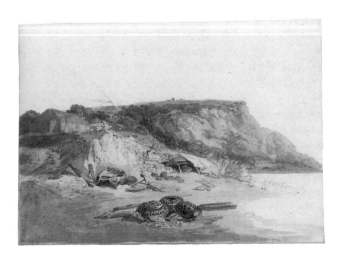

Turner's tour to the Isle of Wight probably took place in August or September of 1795, a month or two after his return from South Wales. This is the only sketchbook used on the tour; it contains a number of fresh colour sketches like 'Colwell Bay', as well as studies of towns made en route, such as Salisbury, Winchester and Southampton. 'Colwell' was engraved by J. Landseer in

c.1799 for a series of views in the Isle of Wight, but mistitled 'Shanklin Castle' (Rawlinson 37a; an impression is in the British Museum, 1893–6–12–158). The series appears never to have been completed.

17 **The Entrance to the Great Hall of the Bishop's Palace, St. David's** 1795–6
Pencil and watercolour over a grey washed ground in lower half of the sheet
411 × 257 ($16\frac{3}{16}$ × $10\frac{1}{8}$)
Turner Bequest; XXVIII C
D00688

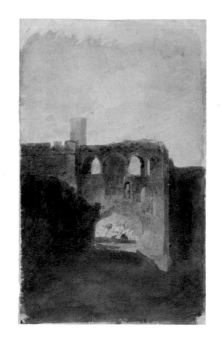

The decay of the Bishop's Palace at St. David's dates from the time of Bishop Barlow in the early sixteenth century, who stripped the lead from the great hall thus intending, so local tradition asserts, to provide for his five daughters, all of whom subsequently married bishops. This watercolour is probably a study for a commissioned work for a 'Mr Lambirt' whose name is inscribed on the preliminary pencil study in the *South Wales* sketchbook (TB XXVI 39), although no finished watercolour was ever produced. With its bold emphasis on silhouette, and the contrast between partially worked areas of masonry with broadly handled areas of pure wash, it can be compared with similar subjects painted by John Sell Cotman (1782–1842) and John Varley (1778–1842) early in the following century.

18 **Llandaff Cathedral: the West Front*** 1795–6
Pencil and watercolour
356 × 255 (14 × $10\frac{1}{16}$)
Turner Bequest; XXVIII A
D00686

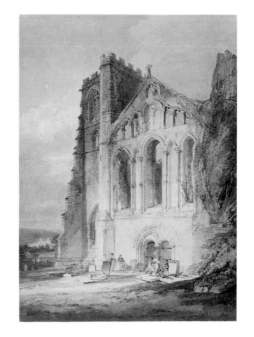

Most of Turner's finished topographical watercolours dating from the 1790s were sold directly to the patrons who commissioned them or at exhibition, and thus are not numerous in the Turner Bequest. 'Llandaff', almost certainly the work of the same title exhibited at the Royal Academy in 1796, was probably destined for the 'Dr Matthews' whose name appears on the reverse of the study for the subject in the *South Wales* sketchbook (TB XXVI 4), although he evidently failed to claim it. It resembles other watercolours of Gothic cathedrals by Turner dating from the 1790s in which the building is presented from a low view point and from an angle so as to heighten the impression of scale and grandeur. In this example a more intimate note is struck by the two young girls dancing on a tombstone to the music of a fiddler, perhaps intended as a comment on youth and age.

19 **Fishermen Hauling a Boat through Surf on a Windlass*** *c.*1796
Pencil, watercolour and bodycolour on buff paper
194 × 269 ($7\frac{5}{8}$ × $10\frac{9}{16}$)
Turner Bequest; XXXIII Q
D00888

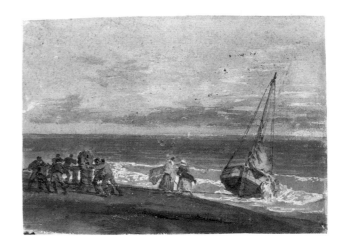

This belongs to a group of marine studies in the Turner Bequest once though to have been painted at Brighton (one of them, TB XXXIII K, shows a boat with the letters BRI...TON inscribed on its transom) but which it is now believed are more likely to have been made in Margate (see also cat. nos. 20 and 21). Their subject-matter and technique – all of them are painted in a mixture of watercolour and bodycolour – suggest that they were made in connection with Turner's first exhibited oil, 'Fishermen at Sea' 1796 (Gallery 107).

20 **Fishermen Lowering Sail; a Three-Master under Sail in the Distance** *c.*1796
Pencil, watercolour and bodycolour on buff paper with stopping-out
268 × 350 ($10\frac{1}{2}$ × $13\frac{13}{16}$)
Turner Bequest; XXXIII f
D00903

Most of Turner's marine studies of *c.*1796 (see also cat. nos. 19 and 21) are painted on a coarse, buff absorbent paper resembling the 'sugar paper' used by grocers in the nineteenth century to hold cane sugar, and sometimes adopted by watercolourists as a support.

21 **Small Boats beside a Man-of-War** *c.*1796
Pencil, watercolour and bodycolour on buff paper
354 × 593 ($13\frac{15}{16}$ × $23\frac{3}{8}$)
Turner Bequest; XXXIII e
D00902

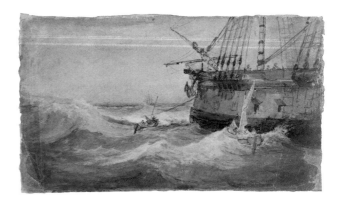

This is the largest of the marine studies of *c.*1796 probably painted in Margate (see under cat. no. 19). Its theme – the vast hull of a man-of-war dwarfing the assorted small craft alongside – was taken up again by Turner some years later in one of his most famous finished watercolours, 'A First Rate taking in Stores', 1817 (w.499) said to have been painted for his Yorkshire patron Walter Fawkes (1769–1825) in the course of a single morning.

22 *Wilson* sketchbook 1796–7
Four Sailors Washing an Upturned Boat
Pencil, watercolour and bodycolour on blue paper
prepared with a red-brown wash
113 × 93 (4$\frac{7}{16}$ × 3$\frac{11}{16}$)
Turner Bequest; XXXVII 112, 113
D01229, D01230

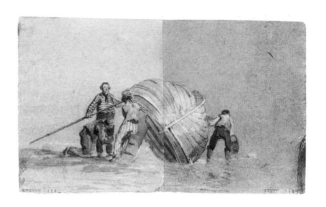

In the late 1790s Turner painted a group of canvases in
the style of the eighteenth-century Welsh landscape
painter, Richard Wilson (?1713–82), the best known
being 'Aeneas and the Sibyl, Lake Avernus' of *c.*1798
(Reserve Gallery 1). His interest in Wilson can first be
documented to 1796–7, the date of this sketchbook, in
which he made a number of copies after the artist's
Italian landscapes. But the *Wilson* sketchbook also
contains a wide range of subjects observed by Turner in
London and the surrounding area – Margate, perhaps,
and north Kent. There are cloud studies, sunsets,
seascapes and church interiors as well as a variety of
charming figure studies like this one, mostly executed in
a combination of watercolour and bodycolour as are a
group of marine subjects of the same date (see
cat. nos. 19–21).

23 **Montecassino** *c.*1796–7
Pencil with blue and grey washes
411 × 562 (16$\frac{1}{8}$ × 22$\frac{1}{8}$)
Turner Bequest; CCCLXXV 34
D36555

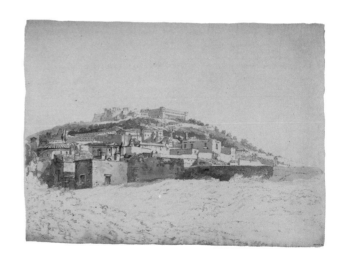

From about 1793 Turner and his colleague Thomas
Girtin were employed by the royal physician and
amateur artist Dr Monro to make copies after other
artists' work, in particular the watercolours of John
Robert Cozens. The diarist Joseph Farington
(1747–1821) recorded that 'Girtin drew in outlines and
Turner washed in the effects'. Many of the drawings of
the 'Monro School' in the Turner Bequest, typically
combining detailed pencil underdrawing with areas of
blue and grey wash, testify to this collaboration. This
watercolour, which may be a copy after Cozens, is a
particularly fine example. On the hillside can be seen
the famous abbey of Montecassino, founded by St
Benedict in 529 AD, which was completely destroyed by
bombs during the Second World War, although it has
now been rebuilt.

24 *Tweed and Lakes* sketchbook 1797
Fountains Abbey; Hubert's Tower from the Chapel of the Nine Altars*
Pencil and watercolour
370×274 ($14\frac{1}{2} \times 10\frac{3}{4}$)
Turner Bequest; xxxv 80
D01082

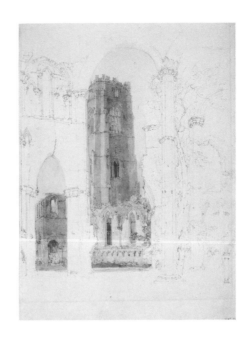

This is one of two large sketchbooks Turner took with him on his tour of the North of England in 1797. In addition to atmospheric studies of Ullswater and Derwentwater, it includes a sequence of careful architectural studies of ecclesiastical monuments in Durham and Yorkshire; this is a good example of one which was left half-finished.

25 **Dunstanborough Castle from the South** 1797
Pencil, grey wash and bodycolour on buff paper with touches of black ink
263×335 ($10\frac{5}{16} \times 13\frac{1}{4}$)
Turner Bequest; xxxvi s
D01113

Having made a sequence of elaborate studies of the ecclesiastical monuments of Yorkshire (see cat. no. 24) and the cathedral at Durham, Turner travelled further northwards on his 1797 tour to sketch the castles of Northumberland – Alnwick, Bamborough, Norham, Warkworth and Dunstanborough. Perhaps inspired by Thomas Girtin who painted three watercolours of Dunstanborough between 1794 and 1797, Turner made a number of experimental studies of the castle in monochrome or coloured washes, based on a pencil drawing in the *North of England* sketchbook (TB xxxiv 45); they were to culminate in an oil painting of the subject shown at the Royal Academy in 1798 (B&J 6; National Gallery of Victoria, Melbourne). This vigorous and broadly handled sketch shows Turner seeking to establish the tonal relationships of the final work.

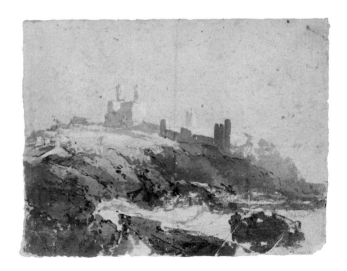

26 **Dunstanborough Castle from the South*** 1797
Pencil, watercolour and bodycolour on buff paper
with touches of black ink
198×278 $(7\frac{3}{4} \times 10\frac{15}{16})$
Turner Bequest; XXXIII S
D00890

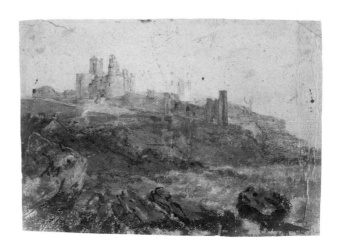

This is another study related to the oil painting of
'Dunstanborough Castle' in the National Gallery of
Victoria, Melbourne (see under cat. no. 25).

27 **Derwentwater, with the Falls of Lodore** 1797
Pencil and watercolour
493×629 $(19\frac{1}{4} \times 24\frac{3}{4})$
Turner Bequest; XXXVI H
D01102

On his return from the North of England in 1797
Turner made a series of studies of the Lake District,
especially of Ullswater and Derwentwater. This water-
colour, showing the view looking south down Derwent-
water to Lodore Falls, is based on a partly coloured
drawing in the *Tweed and Lakes* sketchbook (TB
XXXV 82) which is inscribed on the back 'Mr Faring-
ton'. It in turn formed the basis for the finished
watercolour of 1801 (w.282; Private Collection, Japan)
which Turner presented to Joseph Farington and which
still bears his dedicatory inscription on the verso: 'To
Joseph Farrington Esqre, with W. Turner's Respects'.
In his diary for 24 October 1798 Farington records how,
on visiting the barber's shop run by Turner's father in
Maiden Lane, he was pressed by the artist to select a
subject from the *Tweed and Lakes* sketchbook: 'He
requested me to fix upon any subject which I preferred
... and begged to make a drawing or picture of it for
me'.

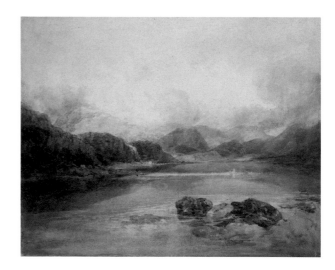

28 Norham Castle: Colour Study* *c.*1798

Pencil and watercolour with stopping-out
662 × 838 (26$\frac{1}{16}$ × 33)
Turner Bequest; L B
D02343

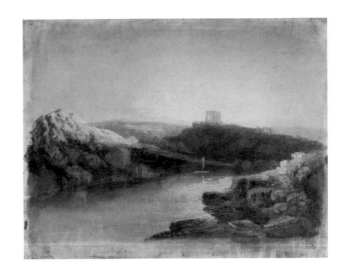

In 1797 Turner recorded the position of Norham Castle high on a cliff above the River Tweed in a single rapid pencil study in the *North of England* sketchbook (TB XXXIV 57). The following year he exhibited a finished watercolour at the Royal Academy, 'Norham Castle on the Tweed, Summer's Morn', which can be identified with one of two versions of the subject known to exist (w.225-6). The idea of showing the ruin evocatively silhouetted against the morning sun appears to have been first developed in two large colour studies in the Turner Bequest, of which this is one. Both show Turner experimenting with rich, dark tones, relieved by considerable areas of stopping-out, most noticeable here in the cows on the bank to the right. The finished version also includes cows drinking in the shallow water in the foreground, a feature retained with modifications in most of Turner's subsequent versions of the subject, most notably the engraving published in 1816 for the *Liber Studiorum* and the famous late oil of *c.*1845-50 (Gallery 101).

29 The Brocklesby Mausoleum *c.*1798

Pencil and watercolour
430 × 636 (16$\frac{15}{16}$ × 25$\frac{1}{16}$) sheet (originally pinned to a drawing board, top margin trimmed); 412 × 605 (16$\frac{1}{4}$ × 23$\frac{7}{8}$) image
Turner Bequest; CXXI U
D08277

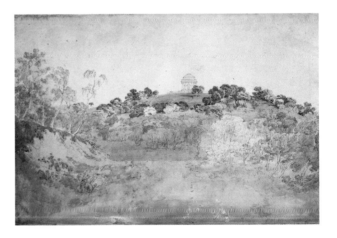

This famous masterpiece by James Wyatt, built for the Earl of Yarborough in the grounds of Brocklesby Hall near Crowle in Lincolnshire, was begun in the late 1780s and completed in 1792. In 1798 Turner made a sequence of drawings of the Mausoleum, from near to and from afar, in the *Brocklesby Mausoleum* sketchbook (TB LXXXIII). This study is based on one of these (TB LXXXIII 3), and may be preparatory to the finished watercolour of the subject commissioned by Yarborough which perished in a fire at Brocklesby Hall in the nineteenth century. A large aquatint of *c.*1800 by F. C. Lewis after Turner (Rawlinson 812) shows the Mausoleum from a nearer viewpoint. The Turner Bequest also contains a watercolour of the interior of the Mausoleum (TB CXCV 130) made by the artist to illustrate the lectures he delivered as Professor of Perspective at the Royal Academy from 1811.

30 Oxford: the Interior of Christ Church Cathedral, Looking Past the Crossing and Organ Screen into the Chancel *c.*1798
Pencil and watercolour with stopping-out
678 × 499 (26⅝ × 19¹¹⁄₁₆)
Turner Bequest; L G
D02348

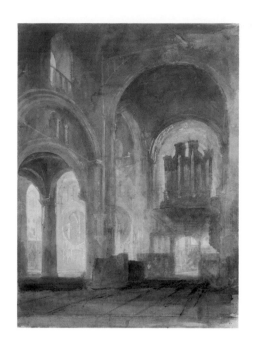

In the latter half of the 1790s Turner painted a sequence of large-scale architectural interiors notable for their rich chiaroscuro, steep perspective lines and sense of soaring elevations – an impression emphasised by their upright format. In this unfinished example, areas of the organ screen and sections of the arches show considerable use of stopping-out.

31 *Hereford Court* sketchbook 1798
A Dark Mountain Side with a Stream Running down it (Cader Idris?)
Pencil and watercolour with scratching-out
332 × 229 (13¹⁄₁₆ × 9)
Turner Bequest; XXXVIII 83
D01337

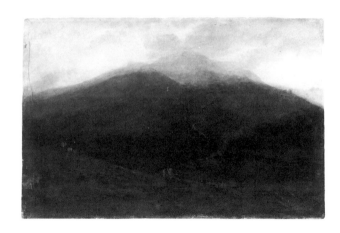

Turner's visit to Wales in 1798 was not only the longest of his Welsh tours, lasting seven weeks, but also the only one in which he visited the whole country. This sketchbook is one of five he took with him that year (see also cat. no. 32); labelled by him on the front cover *South Wales/North Wales*, it contains a wide range of studies which document the whole tour. Many of the coloured sheets are worked up to a considerable degree of elaboration and finish like this one, which probably shows a view of Cader Idris.

32 *Swans* sketchbook 1798–9
The Interior of a Tilt Forge, with Figures 1798
Pencil, pen and black ink with grey wash and some white bodycolour on buff paper
174 × 125 (6⅞ × 4⅞)
Turner Bequest; XLII 60, 61
D01735, D01736

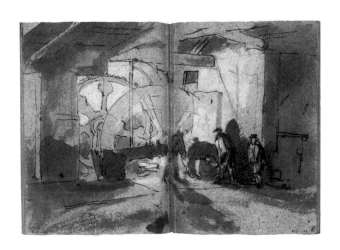

The subject of this sketch has only recently been identified. It is one of a handful of drawings made by Turner in the 1790s which record his interest in scenes of industrial activity: there is a study of what appears to be a naval forge in the *Wilson* sketchbook of *c.*1796-7 (TB XXXVII 102, 3; see cat. no. 22); a watercolour of a foundry (TB XXXIII B) which seems to derive from a sketch made on his tour of the North of England in 1797; and a sequence of detailed pencil drawings of the famous ironworks at Cyfarthfa, Merthyr Tydfil,

executed on his 1798 Welsh tour (TB XLI 1 to 4). Like the majority of subjects in the *Swans* sketchbook, this study is probably also a record of a scene observed by Turner on his Welsh tour of that year; certainly tilt forges, which were chiefly used for the welding of iron, would have been a fairly common sight in the industrial regions of South Wales in the late eighteenth century. A large spur wheel with teeth, resembling that in Turner's illustration, would be powered by an exterior water-wheel with which it revolved in time (about two revolutions a minute). A smaller geared cogwheel would then take up the revolutions of the power wheel, causing the main shaft on which the tilt hammers were fixed (by means of collars) to revolve in turn. As the shaft rotated, the cogs would trip the hammers which then fell on the anvils, at about five or six strikes per second. An example of a tilt forge, built in 1785 and used for the production of crown scythes, can be seen today at the Abbeydale Industrial Hamlet near Sheffield.

33 **Ludlow Castle and Bridge** *c.*1798
Pencil and watercolour
437 × 531 ($17\frac{3}{16} × 20\frac{7}{8}$)
Turner Bequest; XLIV i
D01911

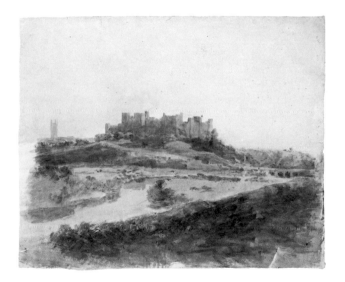

With its palette of earth colours and its free and vigorous brushwork, this naturalistic watercolour of Ludlow from the north-east seems to anticipate Turner's plein-air studies of the following decade. Based on a pencil sketch in the *Hereford Court* sketchbook (TB XXXVIII 63), it is however probably a studio study intended as the basis for a finished watercolour, although it was not until *c.*1830 that it was used by Turner in modified form for one of the subjects in the series *Picturesque Views in England and Wales* (w.825). The *Hereford Court* sketch-book also contains a drawing of the castle from the north-west (TB XXXVIII 11a) on which Turner based two finished watercolours of *c.*1800 where the bridge, spanning the River Teme in the middle distance, forms the focus of the composition (w.264–5). Here, by contrast, the castle acts as a backdrop to a broad stretch of open landscape.

34 The Bend of a River (the Wye?) under High Cliffs *c.*1798
Pencil and watercolour with stopping-out
269×377 ($10\frac{9}{16} \times 14\frac{15}{16}$)
Turner Bequest; L M
D02354

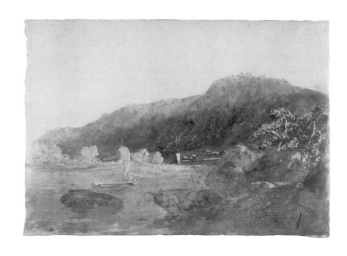

This is another of Turner's watercolours dating from *c.*1798 which shows him experimenting with stopping-out (see also cat. nos. 28 and 30), a technique he seems to have first developed about two years before.

35 Pembroke Castle* *c.*1798
Pencil and watercolour with stopping-out
289×416 ($11\frac{3}{8} \times 16\frac{3}{8}$)
Turner Bequest; XLIV A
D01877

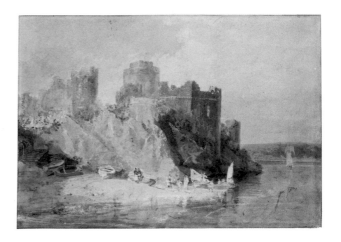

Although dateable to *c.*1798, this subject cannot be connected with Turner's Welsh tour of that year but may rather be based on a sketch made three years earlier, when Turner is known to have passed through Pembroke. It is a finished watercolour which was originally laid down by the artist on his own lined mount (see under cat. no. 12), although this has now been removed. The thirteenth-century castle at Pembroke was badly damaged during the Civil War, when it underwent a Parliamentarian siege lasting 48 days in 1648; it was used as a quarry for over 200 years until the first restorations took place in the late nineteenth century.

36 View towards Snowdon from above Traeth Bach, with Moel Hebog and Aberglaslyn?* 1798-9
Pencil and watercolour with stopping-out
664×850 ($26\frac{1}{8} \times 33\frac{1}{2}$)
Turner Bequest; XXXVI U
D01115

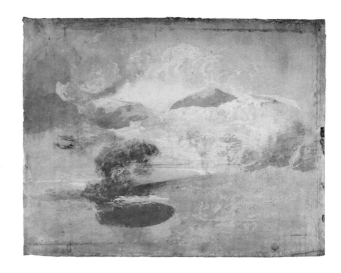

This is one of a group of three large colour studies, probably worked up by Turner in the studio soon after his return from his tour to Wales in 1798, which are characterised by the same light tonality dominated by pale blue. A black chalk drawing in the Turner Bequest (TB LVIII 43), previously considered to be one of the 'Scottish Pencils' of 1801, is related to this subject and was probably made about the same time.

37 **Traeth Mawr, with Y Cnicht and Moelwyn Mawr?*** 1799
Pencil and watercolour
545 × 764 (21¼ × 30⅛)
Turner Bequest; LX(a) F
D03647

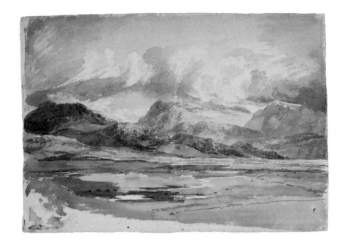

Some of the large colour studies dating from Turner's Welsh tour of 1799 have vertical fold marks across the centre, indicating that they were probably used on the tour itself. Indeed it seems likely that, contrary to his usual practice, Turner may on this occasion have applied colour directly from nature; the broadly applied and limpid wash areas in this example would tend to support such an assumption.

38 **Nant Peris, Looking towards Snowdon?*** 1799–1800
Pencil and watercolour with stopping-out and scraping-out
551 × 770 (21¹¹⁄₁₆ × 30⁵⁄₁₆)
Turner Bequest; LX(a) A
D03642

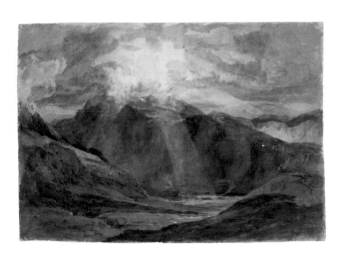

This powerful and sombre watercolour is more finished than the majority of colour studies made by Turner on his return from North Wales in 1799. Several of his views of Snowdonia have not been firmly identified; this watercolour was exhibited four years ago in Wales as a view of Nant Francon from above Llanllechyd but is now thought to show Nant Peris.

39 *Lancashire and North Wales* sketchbook 1799
Caernarvon Castle from the South, with Shipping
Pencil
329 × 225 (12¹⁵⁄₁₆ × 8⅞)
Turner Bequest; XLV 26 (verso)
D01951

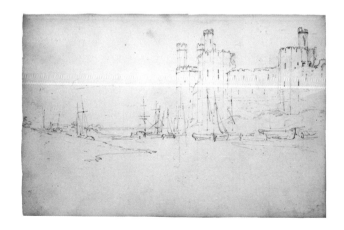

Although the large exhibition watercolour of 'Caernarvon Castle, North Wales' (cat. no. 40) treats an episode from Welsh history, Turner anachronistically includes modern shipping in the distant harbour. There are other studies of shipping in the harbour at Caernarvon in this sketchbook, as well as one in the *Hereford Court* sketchbook (TB XXVIII 93) used in the previous year.

40 **Caernarvon Castle, North Wales*** 1799–1800
Pencil and watercolour with scraping-out and
stopping-out (mounted by the artist on thin board,
washed grey)
700 × 1040 ($27\frac{9}{16} \times 40\frac{15}{16}$) mount;
660 × 994 ($26 \times 39\frac{1}{8}$) image
Turner Bequest; LXX M
D04164

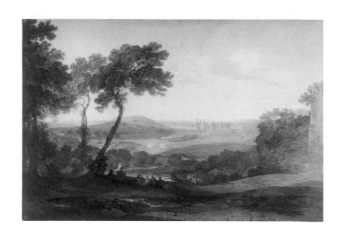

As well as the series of large colour studies executed on
his return from Wales in 1799 (for example, cat. no. 38),
Turner planned a group of watercolours relating to the
story of the extermination of the Welsh Bards by
Edward I (see also cat. no. 41). 'Caernarvon' is the only
watercolour in the group which is finished. It was
exhibited at the Royal Academy in 1800 with lines of
verse, possibly written by Turner himself, referring to
the imminent invasion of Edward I and its destructive
consequences:

> And now on Arvon's haughty tow'rs
> The Bard the song of pity pours,
> For oft on Mona's distant hills he sighs,
> Where jealous of the minstrel band,
> The tyrant drench'd with blood the land,
> And charm'd with horror, triumph'd in their cries,
> The swains of Arvon round him throng,
> And join the sorrows of his song.

41 **Looking down a Deep Valley towards
Snowdon, with an Army on the
March** 1799–1800
Watercolour with stopping-out
679 × 1000 ($26\frac{1}{2} \times 39\frac{3}{8}$)
Turner Bequest; LXX Q
D04168

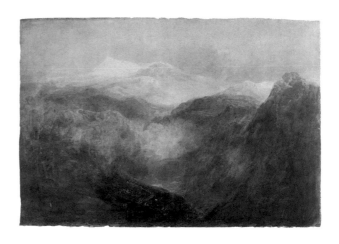

Showing an army train threading its way along a
narrow valley surrounded by bleak and hostile moun-
tains, this watercolour probably illustrates the following
lines from Gray's ode 'The Bard':

> Such were the sounds that o'er the crested pride
> Of the first Edward scatter'd wild dismay,
> As down the steep of Snowdon's shaggy side
> He wound with toilsome march his long array.

Although unfinished, it may have been planned by
Turner as a pendant to the contrasting pastoral scene of
'Caernarvon Castle' exhibited in 1800 at the Royal
Academy (cat. no. 40). Its composition anticipates that
of the oil painting 'Snow Storm: Hannibal and his
Army Crossing the Alps' of 1812 (Gallery 107) which
similarly depicts man's struggle with the forces of
nature.

42 **View over the Lake at Stourhead** ?1799
Pencil and watercolour with scraping-out and
stopping-out
442×595 ($17\frac{3}{8} \times 23\frac{1}{2}$)
Turner Bequest; XLIV g
D01908

It was probably in 1795 that Turner first visited
Stourhead and saw Sir Richard Colt Hoare's distin-
guished collection of Old Master paintings and the
famous gardens created to a Claudian model by his
grandfather in the 1740s and 1750s, with an ornamental
lake and neatly sited temples, cottages, monuments and
sculpture. This is one of two unfinished studies in the
Turner Bequest (see also cat. no. 43), both dating from
towards the end of the decade, showing the view looking
eastwards over the lake towards the temple of Flora,
with Stourton church beyond. In both drawings the sun
is seen just above the horizon, indicating that the scene
is probably intended as sunrise; the extensive rubbing
and scraping-out in the sky in this example is probably a
deliberate (if subsequently abandoned) attempt by
Turner to show the sunrise rather than being the result
of studio damage.

43 **View over the Lake at Stourhead** ?1799
Pencil and watercolour
416×544 ($16\frac{9}{8} \times 21\frac{1}{2}$) sheet;
404×540 ($15\frac{15}{16} \times 21\frac{1}{4}$) image
Turner Bequest; XLIV f
D01918

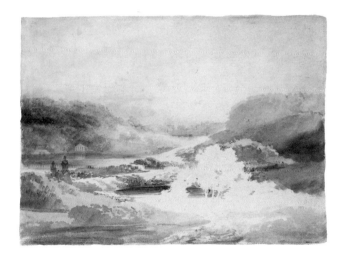

This is a less finished version of catalogue number 42.
Another watercolour in the Bequest, similarly painted
in blue and grey washes and also unfinished, shows a
'View of the Bristol Cross, above the Lake at Stourhead'
(TB XLIV e). It is possible that all these studies were
made in connection with a commission from Colt
Hoare, although no finished watercolours of these
subjects are known.

44 Near View of Fonthill Abbey from the South-East 1799

Pencil

333×467 ($13\frac{3}{16} \times 18\frac{3}{8}$)

Inscribed: 'Top'; '× Height of the floor';
'× windows'

Turner Bequest; XLVII 5

D02182

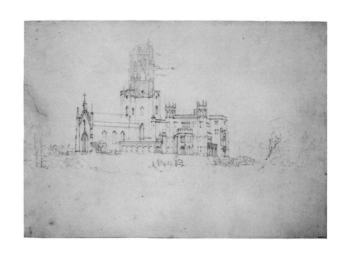

In 1793 the great eccentric William Beckford commissioned James Wyatt (see also under cat. no. 29) to build him a huge Gothic Abbey at Fonthill, in the heart of the Wiltshire countryside. In the late summer of 1799, when the Abbey was still under construction (it was not finished until 1813), Turner spent three weeks there making a series of studies in the *Fonthill* sketchbook (TB XLVII), from which this drawing has been detached. Some are panoramic views (for example cat. no. 45), but others are detailed architectural drawings like this one, which shows the tower as yet incomplete.

45 View across a Valley towards the Tower of Fonthill Abbey, from the North-East*

*c.*1799–1800

Pencil, watercolour and bodycolour

332×469 ($13\frac{1}{16} \times 18\frac{9}{16}$)

Turner Bequest; XLVII 11

D02188

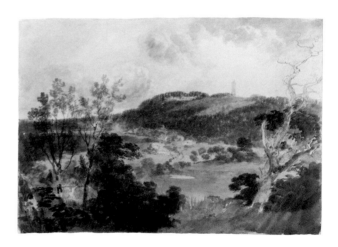

Towards the end of the 1790s Beckford commissioned five large watercolours from Turner showing Fonthill Abbey at different times of the day. This watercolour, originally from the *Fonthill* sketchbook (see under cat. no. 44), is a study for the finished view of the Abbey at sunset (w.339; Whitworth Art Gallery, Manchester). All five finished works (w.335–9), which Turner exhibited at the Royal Academy in 1800, show the tower completed although the artist's pencil drawings indicate that it was unfinished at the time of his visit in 1799 (cat. no. 44). It has been suggested that Turner may have had access to Wyatt's plans.

46 **View of Fonthill Abbey** *c*.1800

Pencil and watercolour with stopping-out
1055×711 $(41\frac{1}{2} \times 28)$
Turner Bequest; LXX P
D04167

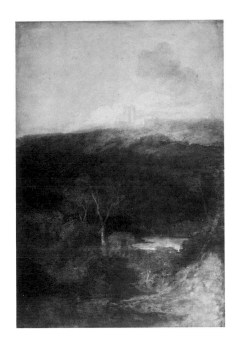

This bold, unfinished watercolour can be compared in its upright format to another colour study of the Abbey in the Turner Bequest (TB XLVII 10). This is the more adventurous of the two in technique, the entire sheet being of a mottled surface texture obtained from repeated sponging or blotting-out, and with prominent use of stopping-out in the foreground trees.

47 **The Siege of Seringapatam** * *c*.1800

Pencil and watercolour with scraping-out and touches of bodycolour
421×654 $(16\frac{5}{8} \times 25\frac{3}{4})$
T04160

This recently acquired watercolour belongs to a group of three views by Turner of the Indian fort of Seringapatam which was captured from Tipoo Sultan in May 1799 by British forces under General Baird during the fourth Mysore War. The other two subjects (see Christie's, 18 March 1986, nos. 107–8) can be identified from the inscriptions on their contemporary mounts: 'HOOLLAY DEEDY, or new Sally-port in the inner rampart of SERINGAPATAM, where Tippoo Sultan was killed, on the 4th May 1799'; and 'RESIDENCE of the Mysore Rajah within the fort of SERINGAPATAM, during the last three years of his confinement'. Since 'Hoollay Deedy' seems to be based on a watercolour made on the spot by the military artist Thomas Sydenham (1780–1816), which is now in the India Office Library, it is likely that the other two were worked up by Turner from material originating from the same source. Until recently all three watercolours were attributed to William Daniell (1769–1837), a topographical artist who specialised in Indian subjects. That the entire group is in fact by Turner cannot now be doubted: an elaborate study for 'The Seige', known to have been in the artist's studio at his death, exists in a private collection; and there is a colour study in the Turner Bequest which appears to be a preliminary design for a fourth Seringapatam subject (cat. no. 48).

The group of watercolours was probably commissioned from Turner about 1800, when the British market was flooded with paintings, prints and drawings commemorating the recent British victory; in 1800, for example, one of his colleagues at the Royal Academy Schools, Sir Robert Ker Porter, painted a large semi-circular panorama of the battle. Turner's watercolour of 'The Seige of Seringapatam' shows the moment when

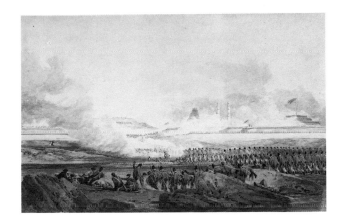

the artillery, having breached the north-west bastion, proceed to cross the River Cauvery. With its inclusion of numerous figures and its depicition of the smoke and turmoil of the battle, 'The Seige' is the most ambitious and elaborate of the three watercolours in the group.

'The Siege of Seringapatam' is also of major importance in being Turner's first surviving battle subject (the painting of the Battle of the Nile which he exhibited at the Royal Academy in 1799 is now lost). A few years later he painted another large watercolour of a battle subject, 'The Battle of Fort Rock, Val d'Aouste, Piedmont, 1796', 1815 (TB LXXX G, W.399) in which the military action is, however, relegated to the distance.

48 **Study of the Ramparts of Seringapatam*** *c*.1800
Pencil and watercolour with some stopping-out
415×655 ($16\frac{3}{8} \times 28\frac{5}{8}$)
Turner Bequest; CXCVI z
D17190

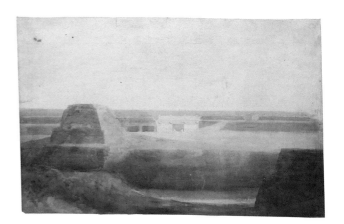

This colour study was formerly assumed to be connected with the illustrations which Turner made for his perspective lectures, and thus to date from the first or second decade of the nineteenth century. Thanks, however, to the recent attribution of a group of three finished watercolours of the fort of Seringapatam to Turner (see under cat. no. 47), its true subject-matter and date can now be identified. The subject corresponds closely with a small, anonymous watercolour in the India Office Library inscribed 'Gateway where Tippoo resided during the siege of Seringapatam'.

Select Bibliography

All books published in London unless otherwise stated

Altick, Richard D., *The Shows of London*, the Belknap Press of Harvard University Press, Cambridge, Mass. and London, 1978

Butlin, Martin and Joll, Evelyn, *The Paintings of J. M. W. Turner*, 2 vols, 1984

Farington, Joseph, *The Diary of Joseph Farington, Volume III September 1796–December 1798*, ed. K. Garlick and A. Macintyre, Yale University Press, 1979

Forrest, Denys, *Tiger of Mysore: the Life and Death of Tipu Sultan*, 1970

Finberg, Alexander J., *A Complete Inventory of the Turner Bequest*, 1909

Finberg, Alexander J., *The Life of J. M. W. Turner RA*, 1961

Hyde, Ralph, *Panoramania*, exhibition catalogue, Barbican Art Gallery, 1988

Joll, Evelyn, 'Turner at Dunstanborough 1797–1834,' *Turner Studies*, Winter 1988, vol. 8, no. 2, pp. 3–7

Kitson, Michael, 'Turner yng Nghymru', review of exhibition 'Turner in Wales' (Mostyn Art Gallery, 1984) in *Turner Society News*, no. 34, No. 1984, pp. 8–11

Lees-Milne, James, *William Beckford*, Tisbury, Wiltshire, 1976

Peatman, Janet, *Abbeydale Industrial Hamlet*, guidebook pub. by Sheffield City Museums, 1981 (second edn 1985)

Rawlinson, W. G., *The Engraved Work of J. M. W. Turner, R.A.*, 2 vols, 1908–1913

ed. Tomes, John, *Blue Guide: Wales and the Marches*, 1979 (sixth edition)

Wilkinson, Gerald, *Turner's Early Sketchbooks: Drawings in England, Wales and Scotland*, 1972

Wilton, Andrew, *The Life and Work of J. M. W. Turner*, 1979

Wilton, Andrew, *Turner in Wales*, exhibition catalogue, Mostyn Art Gallery, Llandudno, 1984

Wilton, Andrew, *Turner in his Time*, 1987

Wilton, Andrew and David Blayney Brown, 'The Siege of Seringapatam', Picture Notes, *Turner Studies*, Summer 1988, vol. 8, no. 1, p. 59

Wilton, Andrew, *J. M. W. Turner: the 'Wilson' Sketchbook*, Tate Gallery, 1988

Wilton, Andrew, Forthcoming catalogue of works on paper in the Turner Bequest 1787–1802

Woodbridge, Kenneth, *Landscape and Antiquity: Aspects of English Culture at Stourhead, 1718–1838*, 1970

Woodbridge, Kenneth, *The Stourhead Landscape*, The National Trust, 1982 (reprinted 1986)